Oxford and the
Pre-Raphaelites

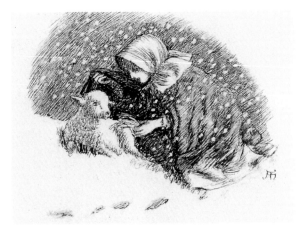

Arthur Hughes

Illustration for Christina
Rossetti's, *Sing-Song*

Ashmolean · Christie's handbooks

Oxford and the
Pre-Raphaelites

Jon Whiteley

Series sponsored by

Fine Art Auctioneers

Ashmolean Museum Oxford
1989

Text and illustrations © The University of Oxford:
Ashmolean Museum, Oxford 1989
All rights reserved
ISBN 0 907849 94 6 (paperback)

Titles in this series include:
Ruskin's drawings
Worcester porcelain
Italian maiolica

British Library Cataloguing in Publication Data
Whiteley, Jon
 Oxford and the Pre-Raphaelites. (Ashmolean/
 Christie's handbooks)
 1. English arts. Pre-Raphaelite Brotherhood.
 Local associations: Oxfordshire. Oxford
 I. Title II. Ashmolean Museum III. Series
 700'. 92'2.

Cover illustration: *Proserpine* by Dante Gabriel Rossetti

Designed by Cole design unit, Reading
Set in Versailles by Meridian Phototypesetting Limited
Printed and bound in Great Britain by
Roundwood Press, Kineton, Warwickshire

Introduction

The Pre-Raphaelite Brotherhood was formed in
London in September 1848 by five painters, William
Holman Hunt, Dante Gabriel Rossetti, John Everett
Millais, James Collinson and Frederick Stephens,
together with a sculptor, Thomas Woolner and a
writer, William Michael Rossetti, Dante's brother.
Although the painters outnumbered the others, the
idea of Pre-Raphaelite sculpture was taken seriously
in the early years and poetry, always important,
became increasingly influential in Rossetti's circle.
It is difficult to think of another group of artists that
wrote so much poetry or painted so many pictures
inspired by it. The 'List of Immortals', those who
'revealed vast visions of beauty to mankind', which
Hunt and Rossetti compiled in 1848, includes
surprisingly few painters before Raphael. Christ,
with five stars, heads the list; the remainder is
dominated by poets. Shakespeare and the author of
Job alone occupy the second division; Leonardo da
Vinci is the only painter in the third division which
otherwise includes Dante, Chaucer, Keats, Shelley,
Landor, Thackeray and Homer; apart from Fra
Angelico (included, no doubt, more for his blameless
life than for his art) and Raphael, both of whom
appear in the fourth division, painters appear
prominently only in the lowest class and even here,
the choice, which includes Hogarth, Giorgione,
Titian, Tintoretto, Poussin, Michelangelo and Wilkie,
is hardly 'Pre-Raphaelite' in any obvious sense.
The list shows that Rossetti, in particular, had a
passionate taste for romantic and medieval
literature, that Hunt had read Ruskin's praise of the
Venetians in *Modern Painters* and that neither knew
very much at all about Italian art before the age of

Raphael. 'They intend' said John Ruskin, in a letter to *The Times* in 1851 'to return to early days in this one point only – that, so far as in them lies, they will draw either what they see, or what they suppose might have been the actual facts of the scene they desire to represent, irrespective of any conventional rules of picture-making and they have chosen their unfortunate tho' not inaccurate name because all artists did this before Raphael's time, and after Raphael's time did not this but thought to paint fair pictures rather than represent stern facts'.

This is very curious as a description of art before Raphael. Even as an account of the Pre-Raphaelites, it is only partly true, describing Hunt's painstaking imitation of the natural world, but making no allowance for Rossetti's stylish evocation of the Middle Ages which combined uneasily with the Pre-Raphaelite ideal of 'stern facts' and became, in time, an alternative to it.

Rossetti entered the Royal Academy School in 1844 but was bored by the curriculum which left little space for the imagination. He turned for help in 1848 to Ford Madox Brown, a painter who was about eight years older than Rossetti and his friends and who, unlike them, had seen early Italian art in Italy at first hand. More importantly, during his stay in Rome, Brown had been influenced by the Pre-Raphaelite taste of the Nazarenes, a group of German artists in Rome who had, like the Brotherhood, reacted against their academic training and had turned to the early Italians for an alternative to the dark paint and conventional gestures and expressions of the art school. It is not surprising that Rossetti, whose father was a Dante scholar and Professor of Italian literature

at King's College, found the early Italian manner of Brown's work so attractive. Rossetti identified, obsessively, with his namesake, Dante Alighieri, the thirteenth century poet whose introspective, autobiographical romance, the *Vita Nuova* (New Life), inspired many of his pictures.

Poetry also brought Rossetti and Hunt together for the first time. Hunt sent a picture inspired by an episode from the *Eve of St. Agnes* to the Royal Academy exhibition in 1848 which attracted Rossetti who also admired the poetry of Keats. He introduced himself to Hunt who, in turn, introduced himself to his protégé, the talented and likeable John Everett Millais. Unlike Hunt or Rossetti, Millais did not have the temperament to be a great original, but he was a ready convert.

For a time, the Brotherhood followed a common purpose. Their drawings acquired a spiky similarity which is present but less evident in their finished works. They adopted a manner of painting on a wet, white ground, based on the ancient technique of fresco painting, which was slow, difficult and unconventional but gave brilliant luminosity to their colours. Rossetti tended to use colour symbolically but Hunt based his colours on an uncompromisingly fresh study of the natural world. Hunt also painted the accessories with a myopic attention to the smallest detail not simply for the sake of realism but because, like all the Pre-Raphaelites, he elaborated the subject of the picture, as Van Eyck did, in the form of hidden symbols.

Differences of temperament and an inevitable weakening of their youthful enthusiasm for conspiracy led to the breakup of the Brotherhood in

8

the early 50s. The Pre-Raphaelite labour of the hand and eye became too troublesome for Rossetti who began to specialise in visionary scenes, inspired by poetic sources, painted in gouache. Millais, too, following his marriage to Ruskin's ex-wife in 1855, gave up the time-consuming techniques of the Brotherhood for the vilified but conveniently rapid manner of Reynolds and Velasquez. Stephens became a writer. Collinson, after a spell as a novice in a Roman Catholic monastery, became a conventional genre painter. Of the founders of the original Brotherhood, only Hunt remained true to his principles of earnest hard-work and high-minded themes while Rossetti's decorative, poetic work offered an exciting and less laborious alternative to a younger generation.

As will become clear from this book the Pre-Raphaelites were closely connected with Oxford. The religious sentiment and symbolism of their first works owed much to the High Church Revival – the Oxford Movement – and in all its phases Pre-Raphaelite art owed something to John Ruskin who was an undergraduate at Christ Church and returned later in his life to the University as Slade Professor. Some of the Pre-Raphaelites' earliest and most important patrons lived in Oxford – above all Thomas Combe whose collection of paintings is now in the Ashmolean Museum. It was in the Oxford Union that their most important attempt at mural painting was made. Burne-Jones and Morris discovered Rossetti's art when they were undergraduates in Exeter College and the Aesthetic movement into which one strand of Pre-Raphaeliteism developed, originated in Oxford.

Ford Madox Brown 1821–1893

1 *The Seeds and Fruits of English Poetry*
Oil on canvas, 36 × 46 cm
Inscribed: FORD MADOX BROWN DEST IN ROMA. 1845. COLORAVIT
IN HAMPSTEAD. 1853.

Seeds and Fruits was planned in London and composed in Rome in 1845. 'During my sojourn', Brown recalled, 'Italian art had made a deep and, as it proved, lasting impression on me, for I never afterwards returned to the sombre, Rembrandtesque style I had formerly worked in'. The influence of the Italian artists before Raphael is obvious in the triptych-like format, in the gothic arches, in the six poets arranged like saints on a gold ground in the wings of a medieval altar piece and in the bright colour. However, in 1851, when Brown finished the large picture, for which this is a study, he omitted all the gothic detail and, later, justified the bright colour as a novel attempt to introduce effects of bright sunlight into painting. Brown, by the early 50s, had succumbed to the Pre-Raphaelite ideal of 'truth to nature' but not before he had given his disciple, Rossetti, a lasting taste for the art of the 'Early Christians'.

The centre panel shows Chaucer reading at the court of Edward III with his patron, the Black Prince, on his left. In the wings appear the 'fruits' of English poetry: Milton, Spenser and Shakespeare on the left; Byron, Pope and Burns on the right; Goldsmith and Thomson in the roundels; and the names of Campbell, Moore, Shelley, Keats, Chatterton, Kirke White, Coleridge and Wordsworth are written on the cartouches held by the standing children in the base.

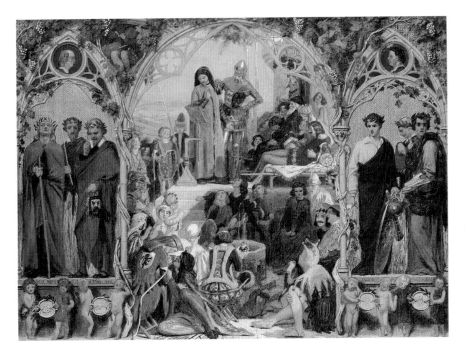

11

John Everett Millais 1829–1896

2 *Portrait of Ford Madox Brown*
Water-colours over pencil, 11.4 cm
Inscribed: JEM 1853.

Although older than the other Pre-Raphaelites and never
formally admitted to the Brotherhood, Brown was an
important member of the circle.

John Everett Millais

The Apple Gatherers

Ford Madox Brown

3 *The Pretty Baa-lambs*
Oil on panel, 20 × 26 cm
Inscribed: F Madox Brown. 52

The Pre-Raphaelite passion for accurate observation
brought artists into the open air with their paint and
canvas. Brown began the original *Baa-lambs*, of which
this is a variant, in 1851, posing his lay figure in hot
sunlight at his home in Stockwell. His wife, Emma, and
their daughter, Catherine, posed for the main group. The
sheep, brought over each day from Clapham Common,
ate all the flowers in his garden and the hot sunshine gave
the artist a fever. Brown was not the first, nor the last,
Pre-Raphaelite to discover the trials of working out of
doors. The rich, sun-drenched effect was, as Brown
insisted, the main subject of this picture but, if so, it is not
obvious why the figures are dressed in eighteenth
century costume. The Ashmolean picture, painted in the
studio of Thomas Seddon in 1852, is a small replica of the
original, now in Birmingham. The background probably
shows the appearance of the Birmingham picture before
the landscape in it was extensively repainted in 1859 by
the artist.

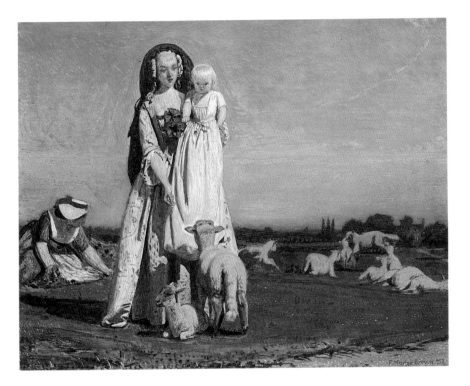

15

Arthur Hughes 1832–1915

4 *The Eve of St. Agnes* (centre panel)
Oil on board, 27 × 31 cm

This picture is a study for a larger triptych (now in the
Tate Gallery) which Hughes exhibited in 1856. The study
originally belonged to the sculptor, Alexander Munro,
with whom Hughes shared a studio in the mid 1850s. The
combined types of lighting in the episodes which Hughes
selected from Keats's poem, recall Hunt's preoccupation
with similar effects. The division of the composition into
three panels, in the manner of a medieval alterpiece, was,
no doubt, inspired by Brown (see fig. 1) and Rossetti.
Hunt, too, certainly inspired the right hand panel, the
escape of Porphyro and Madeline from the castle, which
Hunt had painted in 1848. But Hughes depicted Keats's
Eve of St. Agnes with a sensitivity to the verse that was
alien to Hunt (who was the least poetic of the group) and
to Rossetti who imposed his personal vision on everything
he painted. Like Millais, he had a marvellous talent for
illustration and did his most interesting work, after the
1850s, for publishers.

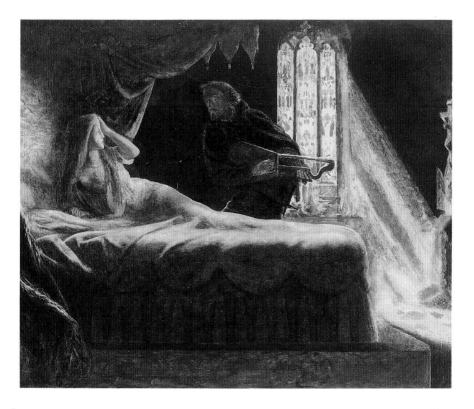

Arthur Hughes

5 *Home from Sea*
Oil on panel, 50 × 65 cm
Inscribed: ARTHUR HUGHES 1862

Hughes, who met Brown, Hunt and Rossetti for the first time in 1850, was an early convert to the art of the Brotherhood. Although less ambitious in his choice of subjects than his friends, he knew how to invest the fresh, light-filled detail of the English landscape with the poignancy of ordinary life. The background of *Home from Sea* was painted in the graveyard of Chingford Church, Essex, in 1856. He exhibited it in 1857 as *A Mother's Grave*. The appearance of the picture, at this stage, is known from a study, by Hughes, in the Ashmolean [see below]. Later, perhaps in response to critics who did not like the way the boy was painted, he added the figure of his sister, which is modelled on his wife, and exhibited this revised version at the Royal Academy in 1863 with the present title. In keeping with the Pre-Raphaelite practise, the detail is not gratuitous but is used to reinforce the pathos of the subject. Ephemeral things – the spider's web, wet with dew, the dog roses, the dandelion seed – all draw attention to the theme of transience while the boy's loss is retold, allusively, in the detail of the sheep separated from its lamb by the barrier of the tomb.

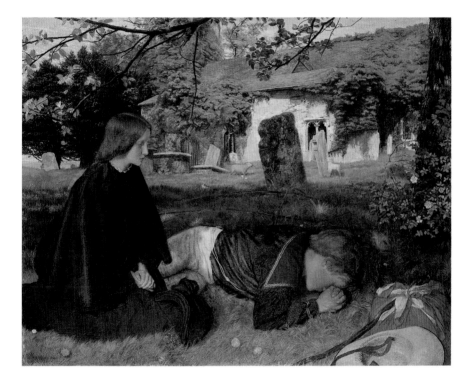

19

John William Inchbold 1830–1888

6 *A Study in March*
Oil on canvas 53 × 35 cm
Inscribed: JWI

Exhibited in 1855 with lines from the first book of
Wordsworth's *The Excursion:*
> 'When the primrose flower
> Peeped forth to give an earnest of the Spring.'

It has been pointed out that the concentration on
the detail of the foreground distinguishes Pre-Raphaelite
landscapes from the older, pastoral tradition in which the
foreground is generally sacrificed to the middle distance.
Despite the danger of spoiling the unity of the composition
by working piece-meal on the details, Inchbold achieves
an astonishing balance of detail and atmosphere, unified
through the delicacy of touch and the natural luminosity
of the colour, thinly laid onto a white ground in the
manner of the Brotherhood. Ruskin, whose influence is
evident throughout the composition, described the effect
as 'exceedingly beautiful'.

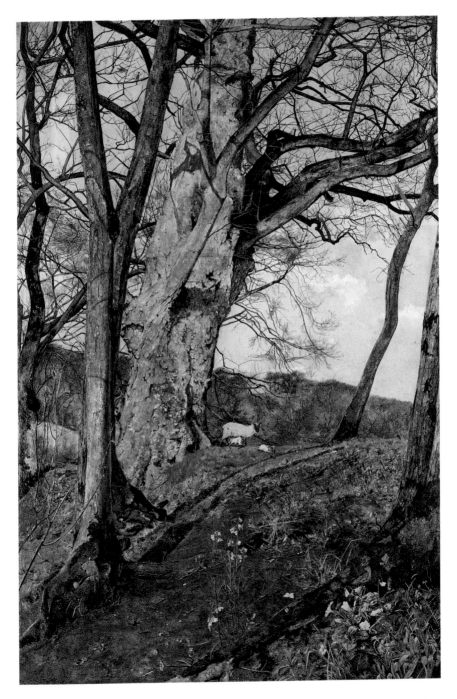

John William Inchbold

7 *The Cuillin Ridge, Skye*
Oil on canvas 51 × 69 cm
Inscribed: J.W. INCHBOLD

This undated landscape has been identified as *The Burn, November – The Cucullen Hills* which Inchbold exhibited at the Royal Academy in 1856. As in *A Study in March,* the real subject, the burn of the title, is concentrated in the foreground. Also, as in the earlier picture, the landscape depicts the light and weather of a particular month, in this case, the chill, sharp light of a November day in North-West Scotland when the sun hardly rises above the horizon. Ruskin, who praised the 'exquisite painting of withered heather and rock' in *The Cuillin Ridge,* commissioned four drawings from the artist and spent two weeks with him in Switzerland in 1858. 'It was' recalled Ruskin, 'a delicate and difficult matter to make him gradually find out his own faults . . . and took me a fortnight of innuendoes. At last I think I succeeded in making him entirely uncomfortable and ashamed of himself and then left him.' It is not obvious that Inchbold was improved by this advice. It is more probable that the 'fortnight of innuendoes' and Ruskin's subsequent indifference to his work profoundly discouraged Inchbold, who had an awkward and retiring character and who never fulfilled the promise of his early paintings.

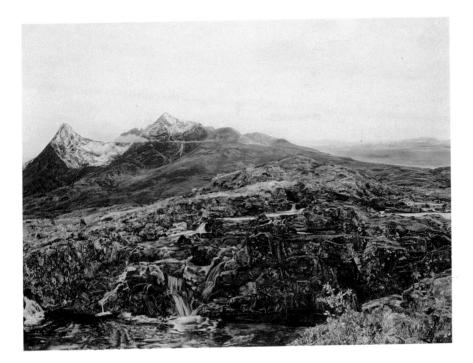

Thomas Combe

The link between Oxford and the Pre-Raphaelites was made first by Millais who arrived in 1846 to visit his half brother. At Oxford, Millais met his first patron, the art dealer and framer, James Wyatt, who provided him with studio space in the High Street in 1849 and commissioned portraits of himself and his family. Millais was not yet a Pre-Raphaelite when he met Wyatt and the most important picture bought by Wyatt from Millais, his *Cymon and Iphigenia,* was painted in the manner of older, academic artists. But Wyatt's support gave Oxford an important place in Millais's earliest Pre-Raphaelite compositions. *Christ in the Carpenter's Shop* was, according to Hunt, inspired by a sermon heard in Oxford and a window in *Mariana* is based on one in Merton College. But it was the landscape of Oxford, the woodlands of Botley and Shotover, which were of real use to the artist who, like Hunt and his friends, often painted the background of pictures in the open air. Oxford also provided the Pre-Raphaelites with their first major patron, Thomas Combe, who made friends with Millais and with his disciple, Charles Allston Collins, in 1850, while the two young artists were painting at Botley. Combe, who made his fortune as printer to the University from 1838 to 1872, spent part of it in building a school and churches for the families of his employees. He supported 'The Oxford Movement', a reforming group within the Church of England which bitterly divided English society in the mid century by attempting to reverse the effects of the Reformation on the liturgy. The hint of Catholic or 'High Church' bias which disturbed some critics in the works of the Pre-Raphaelites, could only have attracted Combe. In the first instance, however, the

24

John Everett Millais

8 *Portrait of Thomas Combe*
Oil on panel, 33 × 27 cm
Inscribed with the artist's monogram and dated: 1850.

Millais and Collins met Combe while they were painting
out of doors at Botley in 1850. Mrs Combe, an ex-pupil of
the watercolourist, David Cox, presided over a good
humoured Salon in her house at the University Press in
Walton Street where this portrait, and a companion
portrait, by Collins, of Martha Combe's uncle, William
Bennett, were painted. According to a label in Combe's
handwriting on the back, Millais painted this portrait in
four sittings of two hours each. The coat-of-arms is that
granted in 1584 to John Combe of Stratford, a friend of
Shakespeare. Combe denied any connection with his
namesake when Hunt asked him about this. But he was
apparently interested in heraldry and decorated the
drawing room where his Pre-Raphaelite collection was
displayed with a frieze of fifty-nine metal shields represent-
ing the arms of the knights who fell at the battle of
Caerlaverock.

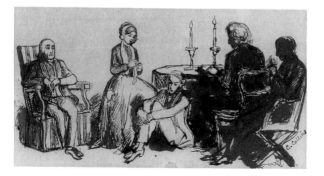

Charles Allston Collins

*The artist and J.E. Millais
with Thomas and Martha
Combe and William Bennett*

26

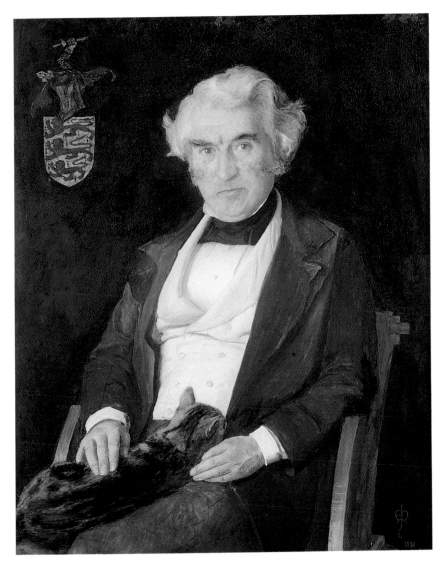

William Holman Hunt 1827–1910

9 *A Converted British Family Sheltering a Christian
 Missionary from the persecution of the Druids*
Oil on canvas, 111 × 141 cm
Inscribed: W. HOLMAN HUNT/1850

Critics savaged the work of the Brotherhood at the Royal
Academy exhibition of 1850 as ugly, incompetent and
blasphemous. This was a severe blow to the hopes of the
young artists. Fortunately Millais had sold his *Christ in
the Carpenter's Shop* to a dealer before the exhibition
opened, but Hunt's *Converted British Family* returned,
unsold, to his studio. The picture started life in 1849 as an
academic set piece on the theme of Mercy but evolved as
Hunt's first major exercise in Pre-Raphaelite painting,
illustrating, in symbolic form, the humanizing effects of
Christianity. The priest, a first century missionary from
Israel, shelters in the house of the converts while a fellow
missionary in the background is driven from the precint
of the Druid's shrine. Hunt took trouble to make the scene
as historical and plausible as he could. At the same time,
he invested the composition with complex allusions to
the Christian mission. The priest, in the foreground, is
presented as the type of the persecuted Christ. The
central group recalls the *Pietà*, the traditional represen-
tation of the Virgin grieving over Christ. The thorns and
sponge refer to Christ's passion; the vine, too, is an
attribute of Christ. This theme is reinforced by the
Biblical texts inscribed by Hunt on the frame which refer
to salvation through suffering and to the quality of mercy.
This elaborate symbolism, with more than a hint of the
High Church, may explain why Millais told Mrs Combe's
uncle, William Bennett, that it would make an appropriate
present for his niece's husband. Combe evidently approved
of the idea. It was his first important Pre-Raphaelite
acquisition. In a long account of the work, sent to Combe
in 1851, Hunt explained that the corn and the cabbages
on the right were intended as an allusion to the civilising
effects of Christianity while the nets, hanging over the
water, refer to the mission of the apostles as 'fishers of
men'.

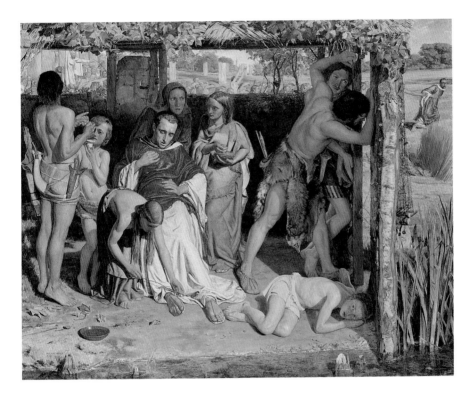

29

John Everett Millais

10 *The Return of the Dove to the Ark*
Oil on canvas, 88 × 55 cm
Inscribed: J Millais 1851

In 1880, Millais began work on an ambitious picture on the theme of the Deluge. His plans for this are known from an expressive drawing in the British Museum and from his letters to Combe in which Millais told his patron that it would compare favourably with a sermon. Millais abandoned this idea and turned instead to a scene inside the Ark in which he intended to include 'several birds and animals, one of which now forms the prey to the other'. But sermonising was not Millais's speciality and he finally adopted the present, less rhetorical solution in which the background, by Pre-Raphaelite standards, is untypically dark. But the detail that remains, the drapery and straw, are painted with astonishing virtuosity. Ruskin, who saw it at the Royal Academy exhibition in 1851, had hoped to buy it, but it had already been sold to Combe, in March, before the opening of his exhibition. Combe hung it on a white wall in his drawing room, on one side of Hunt's *Converted British Family* with Collins's *Convent Thoughts* on the other side.

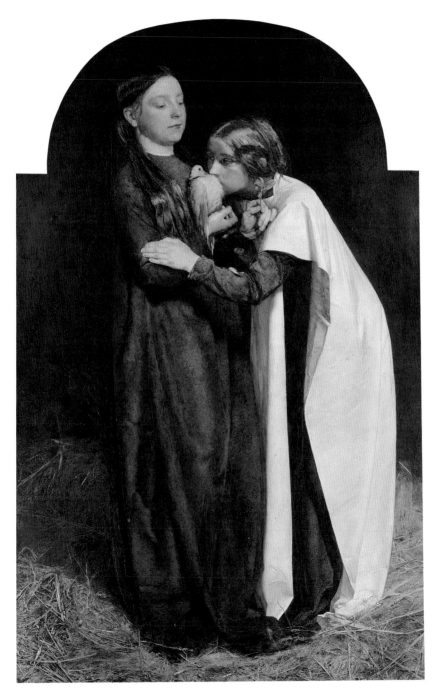

Charles Allston Collins 1828–1873

11 *Convent Thoughts*
Oil on canvas, 84 × 59 cm
Inscribed with the artist's monogram and dated: 51.

Charles Allston Collins, son of the academician, William Collins (and brother of Wilkie Collins, the novelist) was a conventionally academic painter before his friendship with Millais in 1850 led him to change his manner. The background of *Convent Thoughts* was begun in Botley in 1850 when Collins was visiting Oxford with Millais. According to a note by Thomas Combe on the back, the flowers were painted in Combe's garden in Walton Street. The novice was added later, in London using a costume which Hunt had previously used in *Claudio and Isabella*. The sleeves, however, covered the essential missal which the novice holds. Collins admitted that he was tempted to cut the sleeves short: 'It is awkward' he wrote 'in as much as part of the story depends on the hand and the book held in it'. The book, indeed, provides the key to the symbolism. The novice's index finger marks a page illustrating the *Annunciation*, the moment when the angel tells the Virgin that she has been set aside for special grace. She is surrounded by many different species of lily flowers, the Virgin's attribute, which also flank the picture on the frame, designed by Millais and inscribed 'Sicut Lilium', the opening words of a text from the Song of Solomon, conventionally thought to prefigure the Virgin of the New Testament: 'As the lily among Thorns, so is my love among the daughters'. The flower she holds, however, is a Passion Flower, symbol of the Crucifixion, to which her thoughts have turned. We know this as the missal is open at a picture of the Crucifixion.

Convent Thoughts* was exhibited at the Royal Academy of 1851 along with Millais's *Return of the Dove* and Hunt's *Valentine Rescuing Sylvia*. All three were severely attacked by the critics. Millais, again, persuaded Combe to come to the rescue by buying *Convent Thoughts* while Coventry Patmore wrote to Ruskin asking him to write something in the press about the painters who were attempting to paint nature according to his own precepts. Ruskin complied with a famous letter to *The Times* (13 May 1851) in which he warmly defended Collins's botany while glossing over his evident sympathy for Roman Catholicism.

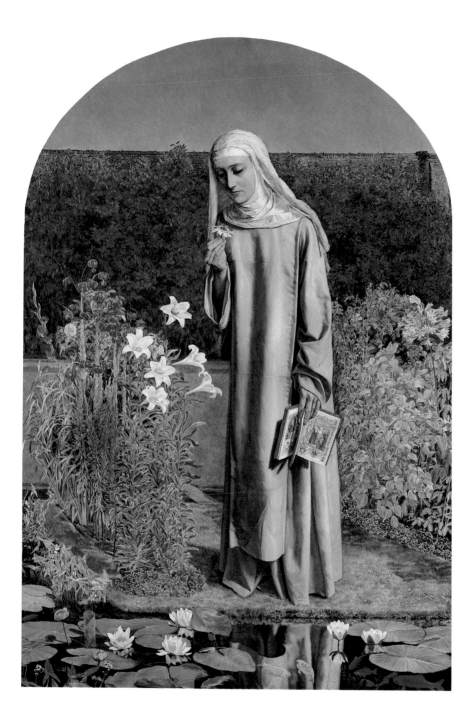

33

William Holman Hunt

12 *The Light of the World*
Oil on canvas, 125 × 59 cm
Inscribed: WHH 1853; and (behind frame): Non me
Praetermisso Domine.
Reproduced by kind permission of the Warden and
Fellows of Keble College, Oxford

The subject was inspired by a text from Revelation: 'Behold, I stand at the door, and knock: if any man hear my voice, and open the door, I will come in to him, and will sup with him, and he with me.' Hunt probably knew a print after a picture on the theme by Philipp Viet, composed in the Early Christian manner of the Nazarenes. Hunt's picture, however, was painted according to different, Pre-Raphaelite principles of painstakingly detailed observation. He set the scene in the hour before the dawn to indicate the coming of the Saviour in keeping with the text: 'The night is far spent, the day is at hand'. (Romans, 13:12). This indicated the lantern and, also, the picture's final title. The winter setting suggests man's lack of grace and the promise of Salvation. Hunt painted the landscape in the orchard of Worcester Park Farm in Surrey, in November and December, 1851, working from 9 pm to 5 am, protected from the cold by a straw hut; he completed the figure in his studio in 1853, using a white robe made from a tablecloth and a brass lamp, made to his design, which gave the artist (and his model) a great deal of trouble by smoking, overheating and going out. Much of the symbolism is obvious: the door of the hut has no handle on the outside so that it can only be opened by the soul within; the weeds indicate that the door had not been opened for a long time; the apples on the ground recall the Fall of Man; other less evident references were explained by Hunt and his friends: the bat, above the door, represents ignorance (because it loves the dark); Christ's clasp represents the tribes of Israel (in the rectangle) joined to paganism (in the circle) by the five wounds of Christ; the seven-sided lantern indicates the seven Churches mentioned in Revelation. Hunt, who met Combe for the first time while painting the *Light of the World*, told him that he had worked on it throughout 'with the hope that it might find its resting place in Oxford'. Combe bought it for four hundred guineas in 1853. After his death, Mrs Combe gave it to Keble College (built in 1868–82 in memory of John Keble, a pioneer of the High Church Movement) where it was installed in a side chapel, specially built for it, with a bequest from Mrs Combe, in 1895.

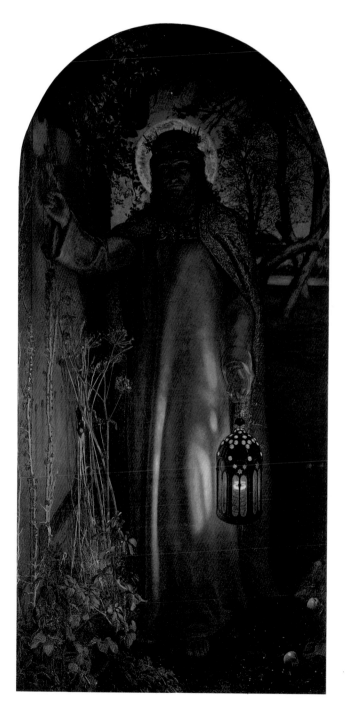

William Holman Hunt

13 *The Afterglow in Egypt*
Oil on canvas, 82 × 37 cm
Inscribed with the artist's monogram

On 13 January 1854, financed by the sale of his
paintings, Hunt left England to travel for two years in the
Near East hoping to rediscover the landscape of the Bible
in Egypt and Palestine. The heat and dust of Egypt and
the Holy Land proved even worse than the cold of
England to the determined Pre-Raphaelite. Writing from
Egypt in 1854, Hunt told Combe that he had begun 'a
study of an Egyptian girl the size of life which however
what with the difficulty of getting the model day by day
and the horrible trials of wind and dust even in the best
places I can find for painting in – is in danger of being
abandoned – at least for the present.' He returned to the
unfinished work (now in Southampton Art Gallery) in
1861, adding the lower half and painting the Ashmolean
version at the same time. Where the model in the
Southampton picture carries a sheaf of wheat, she now
carries a cage of pigeons; the calf and cow are additions;
and the position of her feet has changed, making her less
statuesque. There is probably no special symbolism in
the figure although Hunt admitted that he had posed the
original model with ancient Egyptian statuary in mind.
This debt to Egyptian art is more evident in the
Southampton picture than it is in the Ashmolean version
where Hunt, displeased, perhaps, with the rigidity of the
original, has introduced a not altogether successful effect
of swaying movement. Combe bought this second
version after Hunt had, unsuccessfully, offered to sell it
for three hundred guineas to another patron, Thomas
Plint, in 1861.

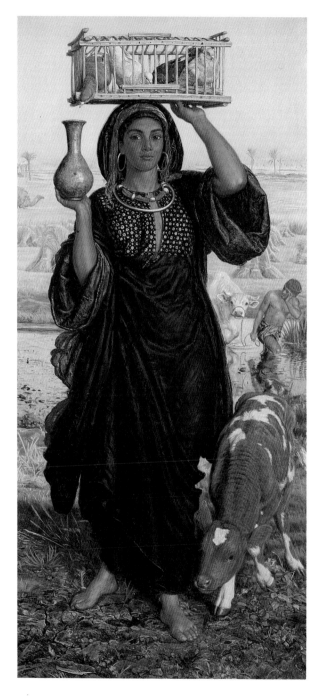

William Holman Hunt

14 *The School-Girl's Hymn*
Oil on panel, 35 × 25 cm
Inscribed: 18 WHH 59

The origin of this picture is given in a note, pasted to the back of the panel, by Combe: 'This represents a girl going to school on a smiling summer Sunday morning, singing her hymn as she walks along. In the summer of 1858, Hunt went to see his friend who was staying at a farmhouse in the neighbourhood of Hastings, he then began this picture which was not finished till 1859. It is a portrait of Miriam Wilkinson, a labourer's daughter – in the spring of 1859 she came up to Kensington that he might finish it.' The picture was finished in October and sent to an exhibition, organised by Ernest Gambart, in November. Combe bought it before the opening. In a letter to Gambart and in another to the keeper of the University Galleries in Oxford, Hunt connected the subject with four lines from Coventry Patmore's *Tamerton Church Tower*.

> 'It was an almshouse scholar trim
> who on her happy way,
> Sang to herself the morrow's hymn,
> For this was Saturday.'

She sings from a book inscribed PSALMS AND HYMNS. But Patmore was probably an afterthought. Hunt, who retouched the picture in 1860 for Combe, referred to it always as a 'pot-boiler', a picture to earn money while the more serious and time-consuming business of his bigger pictures was in hand.

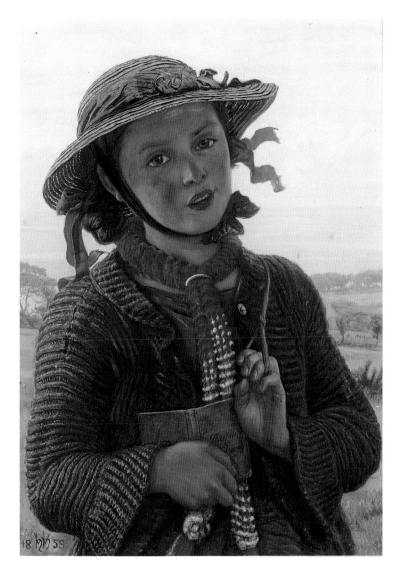

William Holman Hunt

15 *London Bridge on the Night of the Marriage of the Prince and Princess of Wales*
Oil on canvas, 65 × 98 cm
Inscribed with artist's monogram and dated 1863–6

Hunt was present in the crowd on London Bridge on the night of 10 March 1863, celebrating the marriage of Princess Alexandra of Denmark to the future Edward VII. 'The display' Hunt recalled 'made many buildings, by daylight dingy with city smoke, fairy-like and gorgeous. Temple Bar was enlivened by hangings of gold and silver tissue and London Bridge was hung with masts, crimson banners surmounting the Danish insignia of the Elephant; tripod braziers and groups of statuary made up the show of welcome to the Princess on the spot full of memories of Danish exploits of ancient times, and the whole was illuminated by an effulgence of light. Being fascinated by the picturesque scene, I made sketches of it in my notebook, and the next day I recorded them with colour on a canvas. When I had completed this, the Hogarthian humour that I had seen tempted me to introduce the crowd; but to do this at all adequately, grew to be a heavy undertaking'. The picture was not ready for exhibition until 16 May 1864 and was retouched in 1866. The 'Hogarthian' element (which surprised the critics) reflects Hunt's interest in the 'stalwart founder of Modern English Art' as he described Hogarth. This was not Pre-Raphaelitism as Rossetti understood it, but Hogarth's art of moral commentary was congenial to Hunt and his friends who named a short lived club for Pre-Raphaelite artists and their friends after him. However, as Hunt's account of the scene shows, he was initially attracted to the different effects of natural and artifical lighting combined here, as they are combined in *The Light of the World,* in a single composition. Hunt included portraits of the Combes, along with portraits of other friends in the lower left. This probably encouraged Mrs Combe to buy the picture from the artist after the death of Thomas Combe in 1872. The frame was designed by Hunt with appropriate emblems for a wedding, combined with the royal arms of Denmark and of England.

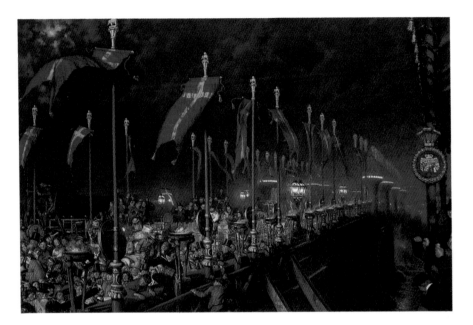

41

The Union murals

In 1855, Rossetti finally arrived in Oxford, following Elizabeth Siddal who had gone there on Ruskin's advice to consult Dr. Henry Acland on the subject of her ill-health. Both were warmly received within the University but not by the Combes who clearly preferred the sober minded Hunt to his Bohemian friends. Combe bought Rossetti's *Dante drawing an Angel* in 1855, but this was the only work by Rossetti in his collection. Ruskin, however, seeing *Beatrice meeting Dante at a Wedding Feast* at an exhibition in 1852, was converted by his seductive colour and became an important ally. An attempt was made to involve Rossetti in decorating the interior of Benjamin Woodward's University Museum, a project in which Ruskin and Acland were deeply involved, but this came to nothing perhaps because the subject suggested to Rossetti, *Newton gathering pebbles on the Shore of the Ocean of Truth,* was not his taste. However, the idea of painting on a wall must have appealed to Rossetti since he offered, instead, to decorate the interior of the Debating Room (now the library) in Woodward's recently completed Union building, in return for nothing but board and lodging. Rossetti brought in six followers to help him to decorate the gallery of the neo-gothic hall with scenes from the Arthurian legends. Apart from Rossetti and Arthur Hughes, none of the team (which included Edward Burne-Jones, William Morris, J.H. Pollen, Valentine Prinsep and Spencer Stanhope) had much previous experience of painting and the mural was abandoned, unfinished, in the Spring of 1858. The Union employed a local artist, William Riviere and his son Briton, a future Royal Academician, to complete the scheme in the

following year. The idea of painting something like an old Italian fresco must have appealed to Rossetti but neither he, nor any of the artists who worked on the murals, had any clear idea of the problems of painting on a wall. They used tempera paint, applied with small brushes directly onto a dry, ill-prepared brick surface and within ten years, the surface had deteriorated. Despite two extensive restorations, the murals are now only a shadow of the colourful originals which were described by Patmore, a colleague of the Brotherhood, as 'sweet, bright and pure as that of the frailest waif of cloud in the sunrise.'

Dante Gabriel Rossetti 1828–1882

16 *Portrait of Elizabeth Siddal*
Pen and brown and black ink with wash, 12 × 11 cm
Inscribed: DGR Feb 6 1855

Elizabeth Siddal was an assistant in a millinery shop in
London when Walter Deverell first employed her as a
model. She met Rossetti in 1850 and became his favourite
model, his mistress and his pupil. As well as drawing in
the manner of Rossetti, she wrote poetry in the style of
Rossetti's sister, Christina. When Rossetti drew this
portrait in 1855, she was a confirmed invalid although the
nature of her illness was never convincingly diagnosed.
Her Oxford physician, Dr Acland suspected it was self-
induced. She married Rossetti in 1860 and died two years
later from an overdose of laudanum. Rossetti's portrait
recalls Georgiana Burne-Jones's description of her at
this time:
'She wore her hair very loosely fastened up, so that it fell
in soft heavy wings. Her complexion looked as if a rose
tint lay beneath the dark skin, producing a most soft and
delicate pink for the darkest flesh tones. Her eyes were of
a kind of golden brown . . . and wonderfully luminous: in
all Gabriel's drawings of her and in the type she created
in his mind this is to be seen. Her eyelids were deep, but
without any langour or drowsiness, and had the peculiarity
of seeming scarcely to veil the light in her eyes when
looking down'.

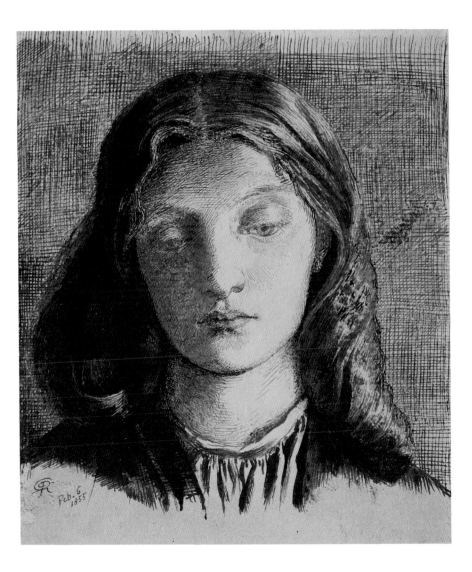

45

Dante Gabriel Rossetti

17 *Dante drawing an Angel on the First Anniversary of the Death of Beatrice*
Water-colour, 42 × 61 cm
Inscribed: DGR/1853.

Influenced by Hunt, Rossetti began work in 1853 on a subject from modern, urban life but did not finish it, finding a more congenial and less demanding form of art in a series of finished water-colours, inspired by medieval sources, which he painted in the 1850s. Rossetti had already made two drawings with the same subject as this large water-colour to illustrate an episode in Dante's *Vita Nuova*: while drawing an angel on the anniversary of Beatrice's death, Dante looks round to find 'that some were standing beside me to whom I should have given courteous welcome – – – Perceiving whom, I rose for salutation and said: "Another was with me." 'Among the visitors, Rossetti included a woman who is not mentioned in the text but who was intended to represent Dante's future wife, Gemma Donati, although Rossetti, himself, was in two minds about this. Elizabeth Siddal modelled for this figure, proving, at least, that Rossetti was not then wholly committed to the idea of identifying her with Beatrice. The accessories illustrate different aspects of the narrative; the ivy is probably an emblem of memory; the skull represents death; the hour glass indicates passing time; the pomegranate is an emblem of Proserpine; the book recalls Virgil's role in the *Divine Comedy*. Along with this Pre-Raphaelite detail, there is a tendency to flatness, particularly noticeable in the frieze of angel heads, which is common to all Rossetti's water-colours in this period. Both Combe and Ruskin liked this composition but Rossetti had already sold it for fifty pounds to Francis McCracken, an early collector of Pre-Raphaelite art. Combe bought it at McCracken's sale in 1855.

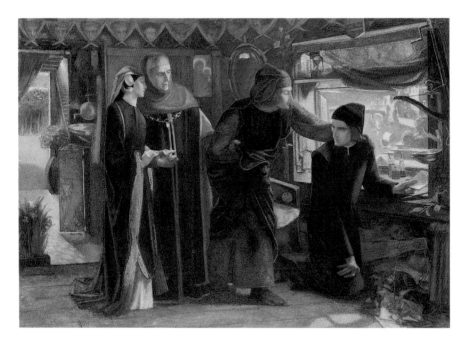

47

18 *Beatrice, meeting Dante at a Wedding Feast, denies him her Salutation*
Water-colour, 34 × 42 cm

In 1848, Rossetti included this subject in a list of proposed illustrations for his translation of Dante's *Vita Nuova*. He exhibited a water-colour on the same theme in 1852 at the gallery of the dealer, Ernest Gambart, where Ruskin saw it. This was Ruskin's first chance to assess the work of Rossetti. He told Holman Hunt that it was 'a *most glorious* piece of colour. The breadth of blue – green – fragmentary gold is a perfect feast.' Rossetti borrowed his water-colour from its first owner in 1855 to make this second, nearly identical version for a client, but Ruskin, in the interim, bought it for himself. The composition follows the broad outlines of Dante's text which describes how the author was overcome by a faint while watching a marriage procession with a friend. 'Whereupon I remember that I covertly leaned my back into a painting that ran round the walls of that house; and being fearful lest my trembling should be discerned of them, I lifted mine eyes to look on those ladies, and then first perceived among them the excellent Beatrice – – – many of her friends, having perceived my confusion, began to wonder; and together with herself, kept whispering of me and mocking me.' Rossetti combined this passage with an earlier episode in which Beatrice, misunderstanding Dante's behaviour, withholds her salutation. Rossetti also added the little girl offering her flowers to Dante as a foil to the scornful attitude of Beatrice.

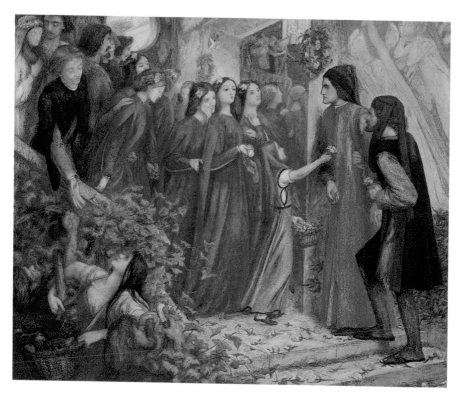

49

Dante Gabriel Rossetti

19 *Sir Lancelot's Vision of the Sanc Grael*
Water-colour and body colour over black chalk,
71 × 107 cm

In 1857, Rossetti chose the theme of Malory's *Morte d'Arthur* to decorate the ten gallery bays of the Union debating hall, promising, optimistically, to paint three of them himself. Of these three – *Sir Galahad receiving the Sanc Grael, Lancelot found in Guenevere's Chamber* and *Sir Lancelot asleep before the Shrine of the Sanc Grael* – only the last, for which this is a preparatory drawing, was more or less finished when Rossetti left Oxford in November. The original is now a ruin but, in the brief period while it was still visible, it was much admired, especially by poetry-minded students at the University. Rossetti, who was an instinctive pattern-maker, made a virtue of the hexafoil windows which awkwardly divide the wall into three areas; on the right, Lancelot lies sleeping; on the left is the shrine of the angels while the vision of Queen Guenevere, holding up the tempting fruit, like Eve, towards the sleeping knight, separates the two, just as, in the narrative, she came between Lancelot and the fulfilment of his quest to find the holy grail.

51

Morris and Burne-Jones

William Morris and Edward Burne-Jones both came
up to Exeter College in Oxford, in 1853, intending to
take holy orders, but the works of Ruskin and the
sight of Pre-Raphaelite paintings in Wyatt's shop and
in Combe's house converted them to the cause of art.
Like other students at the time, they were especially
impressed by Rossetti whose *Dante drawing an
Angel,* a recent addition to Combe's collection, filled
them with 'wonder and delight'. They shared his
nostalgia for medieval art and poetry which they
imitated more attentively than the Pre-Raphaelites
of 1848 had ever done. When Morris decided to train
as an architect, he turned in 1856 to one of the most
inventive neo-Gothic architects of the time, George
Edmund Street, who had an office in Beaumont
Street. Here Morris met Street's senior clerk, Philip
Webb, the future architect, who designed the
'Red House' at Bexley Heath for Morris following
his marriage to Jane Burden in 1859. Webb also
designed furniture for Morris's rooms, first in 17 Red
Lion Square and then for the Red House, massive
mock-medieval pieces, some of which were
decorated by Rossetti, Morris and Burne-Jones in
a strong, flat, heraldic style.

Burne-Jones, meanwhile, took lessons in
painting from Rossetti, developing Rossetti's
languorous ideal and sense of pattern, firstly in
gouache drawings, then in paintings and above all,
in the designs which he supplied to the firm of Morris,
Meade, Marshall and Faulkener, founded in 1861,
with Rossetti, Burne-Jones and Brown as partners.
This enterprise, which originated in the furniture
commissioned by Morris from his friends for his
own rooms, was based on principles of clear, simple

design and on the revival of craft skills. Despite a serious lack of capital in the early years, the firm was, surprisingly, a commercial success and lastingly influenced attitudes to design in England and elsewhere. For an idealist, Morris had an unusual talent for making money. His poems were immensely popular. The Kelmscott Press, founded in 1890 to improve standards of book production, made England, at the end of the century, the centre of art book publishing. But, perhaps because he had never been short of money, he was not satisfied with material success. His ambition to recreate English society in the image of a pre-industrial ideal – an ambition which runs through the history of the Gothic Revival in the nineteenth century, from Pugin and Ruskin to Morris and his followers – was not to be realised by selling expensive, hand-crafted furniture to rich people, and he turned, as others did, to the politics of socialism to find the elusive solution to the problems of the modern world.

Dante Gabriel Rossetti

20 *Proserpine*
Red and black chalks, 97 × 46 cm
Inscribed: DGR 1871

During the summer of 1857, Burne-Jones and Rossetti
met Jane Burden for the first time at the Oxford theatre.
She became a favourite model in Rossetti's circle and
married William Morris in 1859. Her heavy features and
full, black hair became the Pre-Raphaelite ideal of beauty
from this time on, particularly for Rossetti who became
her lover and who painted her obsessively in his late
works. In about 1868, Rossetti began to use her features
in a series of large portraits drawn in red and black chalk,
to which he added poetic and mythological attributes.
This finished drawing relates closely to a painting which
once belonged to L.S. Lowry although it lacks the ivy
tendril, representing 'clinging memory' and the incense
burner, the 'attribute of a goddess' which appear in the
painting. The light square behind her head represents a
shaft of light from the upper world which Proserpine,
according to the myth, unwittingly forfeited by biting
into the fatal pomegranate. Rossetti bequeathed the
drawing to the sitter. Her daughter, May Morris, be-
queathed it in 1939 to the Ashmolean in keeping with her
mother's wish.

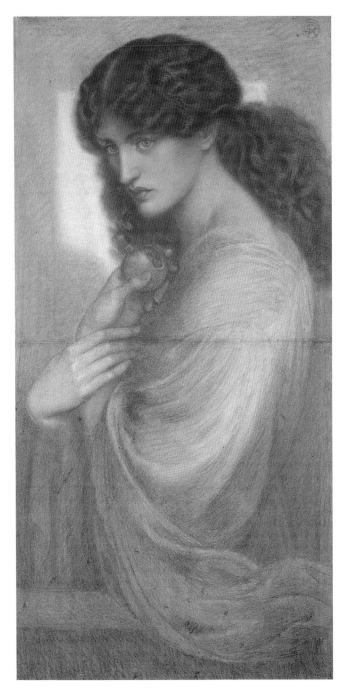

55

Edward Burne-Jones 1833–1898

21 *Cabinet decorated with scenes from 'The Prioress's Tale'*
Oak and deal, painted in oil
Inscribed: EBJ to WM; with texts from Chaucer

According to Jane Burden, this cabinet was given as a wedding present to Morris by Burne-Jones. It was placed, at first, in the principal bedroom of the Red House and followed the Morrises when they moved to London in 1865. Painted presumably, in 1858–9, using Jane Burden as a model, it was Burne-Jones most ambitious painting to date. The folding door on the left is inscribed with the opening verses of Chaucer's *Prioress's Tale* and decorated with different episodes from the poem which decribes how a Christian boy, who had learned to sing the hymn *Alma Redemptoris* at his school, was assassinated by resentful Jews. But the Virgin, by placing a grain upon his tongue, allowed him to continue singing and reveal the crime. The Virgin, placing the grain upon his tongue, appears in the centre of the door. She also appears with angels on the right hand door, over a portrait of Chaucer, holding a stalk of wheat.

It is hard to imagine what inspired Burne-Jones to paint a cabinet with such a disagreeable tale although he did it with an instinctive sense of pattern and a Flemish feeling for the detail and thought well enough of the result to repeat the composition in a later painting.

A series of six, unfinished figures, painted by Morris on the inside of the doors, more appropriately refer to the activities of a dressing room. One of these is a variant of Morris's painting, *Queen Guenevere* of 1858. If the painting on the door is the earlier of the two, this would explain the choice of subject in the finished picture which depicts Jane Burden as Queen Guenevere disrobing in a medieval chamber.

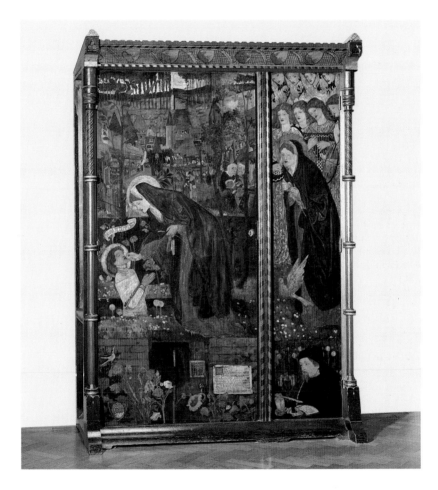

Edward Burne-Jones

22 *An Angel Organist*
Brown and blue washes over pencil, 55 × 58 cm
Inscribed: Lyndhurst 1862, no. 42 Top, F.P.

In 1862–3, Morris's firm designed and supplied the glass for a large, complex east window for St. Michael's Church in Lyndhurst, Hampshire. The tall, main lights are surmounted by a round window, encircled with six trefoils, all glazed following the designs of Burne-Jones. This is the full scale working drawing for the glass in the lowest of the trefoils. There is a similar drawing for an upper trefoil in the Ashmolean [see below] and there are other drawings for the window in Birmingham City Art Gallery, in the Fitzwilliam in Cambridge and in the William Morris Gallery in Walthamstow.

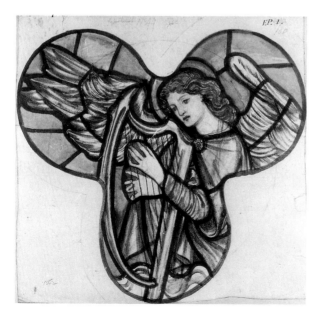

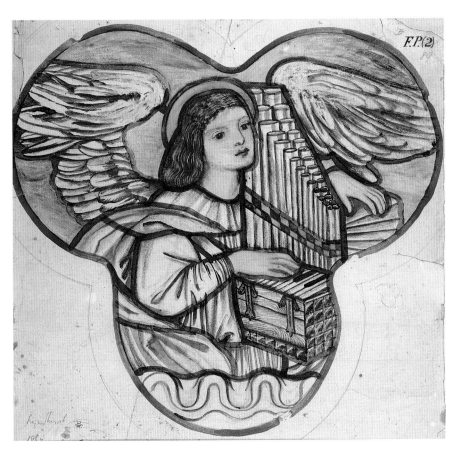

Edward Burne-Jones

23 *Love Leading Alcestis*
Black chalk and water-colour, 135 × 135 cm

In 1863 Ruskin told his friends that he wished to leave
England for ever and settle in his beloved Swiss Alps.
Burne-Jones suggested that he should build a house,
instead, in the Wye Valley and offered to design a set of
needlework hangings, illustrating Chaucer's *Legend of
Good Women,* for one of the rooms. 'First will come
Chaucer, looking frightened according to the poem and
inditing the poem with a thrush on his shoulder – then
comes Love a little angry, bringing Alcestis. Chaucer in
black, Love in red and white and Alcestis in green.'
Alcestis, in Greek mythology, sacrificed her life to save
her husband, Admetus. She became the archetype of the
loving wife. It is quite possible that Burne-Jones designed
the set to console Ruskin who had been abandoned by his
first wife in favour of Millais. The scheme did not come to
much and nothing now remains except a number of full
scale drawings, designed by Burne-Jones as needlework
patterns for the girls at Winnington Hall, a school in
Cheshire which Ruskin supported. Ruskin, who gave this
drawing and one other from the set to the Drawing
School in Oxford, used them to illustrate his lecture 'On
the present state of Modern Art' given at the British
Institution in 1867. The graceful linearity of these
drawings reflects Burne-Jones's increasing interest in
antique and Renaissance art in the early 60s. Ruskin, who
was beginning to tire of Rossetti's gothic manner,
suggested that Burne-Jones's interpretation of Alcestis,
'the Greek womanly type of faithfulness and eternity of
love' had 'gone further into the meaning of the old Greek
myth and . . . given the spirit of the love that lives beyond
the grave.'

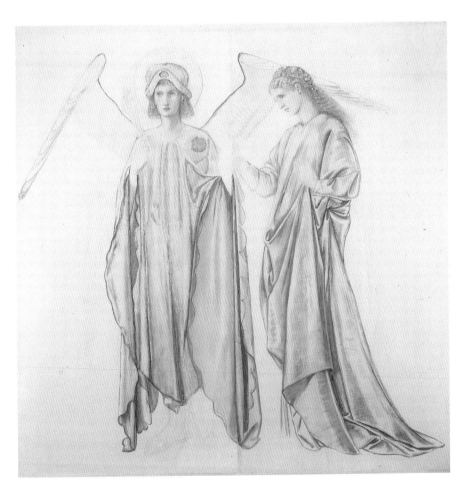

Edward Burne-Jones

24 *St Catherine with two angels and related scenes*
Stained glass
Christ Church Cathedral
© Paul Woodmansterne Publications Ltd

Burne-Jones drew the working models – the 'cartoons' –
for the fourth and last of his windows in the cathedral at
Oxford, in 1878. The window was installed in memory of
Edith Liddell, daughter of Dean Liddell and sister of Alice
Liddell, the original of Lewis Carroll's *Alice in Wonderland*,
in the east window of the south choir aisle, directly across
from the *St. Cecilia* window, installed to Burne-Jones's
design three years earlier. The earliest of his windows in
the cathedral, the *St. Frideswide* window, was designed
in 1859 for the firm of Powell and Son of Whitefriars, one
of a number of important commissions for stained glass
given to Burne-Jones by Powell before 1861 when he
began to work exclusively for Morris. By contrast with
the simple lines, clear forms and bright but restricted
colour of the later windows, the earliest window is richly
subdivided into a mosaic of little details more in keeping
with the medieval tradition of stained glass than his later,
more Italianate designs.

Edward Burne-Jones

St. Frideswide
A study for the figure of
the saint in the upper left
of the St. Frideswide
window in Oxford
cathedral

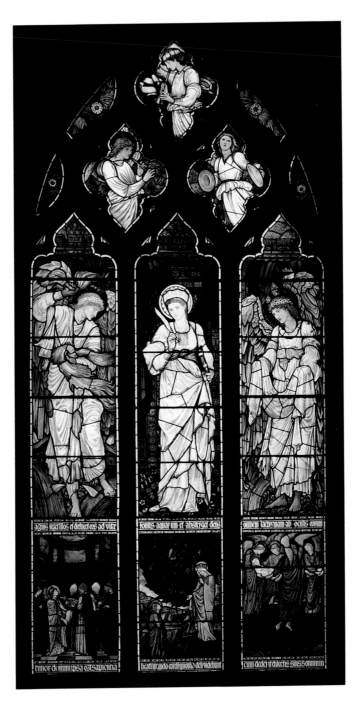

Edward Burne-Jones

25 *The Star of Bethlehem*
High-warp wool tapestry, 264 × 396 cm
Reproduced by kind permission of the Rector and
Fellows of Exeter College, Oxford

In the late 1880s, Burne-Jones, who had been solely
responsible for the figure work in the firm of Morris and
Co. since 1861, began to design tapestries for Morris.
This was a new development for Morris who added
weaving to the manufacture of stained glass, carpets,
embroidery, tiles, furniture, printed cottons and wall-
papers which his workshops produced in increasing
quantities after the firm moved to Merton Abbey, near
London, in 1881. Morris, who abominated the French
habit of reproducing oil paintings in the alien medium of
wool, taught himself the art of weaving and passed the
skill on to his own craftsmen. The *Star of Bethlehem*,
designed in 1887 for the Chapel of Exeter College where
Burne-Jones and Morris had met as undergraduates,
was the firm's first, large-scale attempt at making
tapestry. The pattern of figures, moving up and down the
surface of the tapestry against a rich, flattened back-
ground of flowers and trees, recalls the decorative
paintings of Filippo Lippi and his contemporaries in the
early Florentine Renaissance, although there is no direct
source for the composition.

64

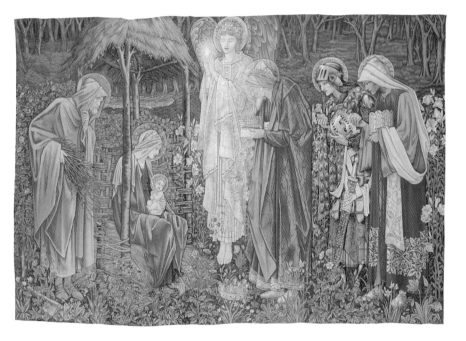

Edward Burne-Jones

26 *Danae and the brazen Tower*
Oil on panel, 38 × 19 cm
Inscribed: E.B.J.

Warned by an oracle that his daughter's son would one day kill him, Acrisius, King of Argos, imprisoned his daughter, Danae, in a tower of brass. In due course, however, she bore a son to Jove who slew his grand-father as the oracle had predicted. In Burne-Jones's painting, Danae anxiously watches the workmen enclosing the tower in curved plates of brass. Like many of Burne-Jones's Greek subjects, the story was probably not taken directly from an antique text but from a later source, in this case, from Morris's *Earthly Paradise* which also inspired Burne-Jones's series on the theme of Perseus (Staatsgalerie, Stuttgart), the Pygmalion set (Birmingham City Museum) and the story of Cupid and Psyche (Ashmolean).

Edward Burne-Jones

Psyche gazing at the sleeping Cupid
One of forty-seven illustrations for the tale of Cupid and Psyche in Morris's The *Earthly Paradise*

66

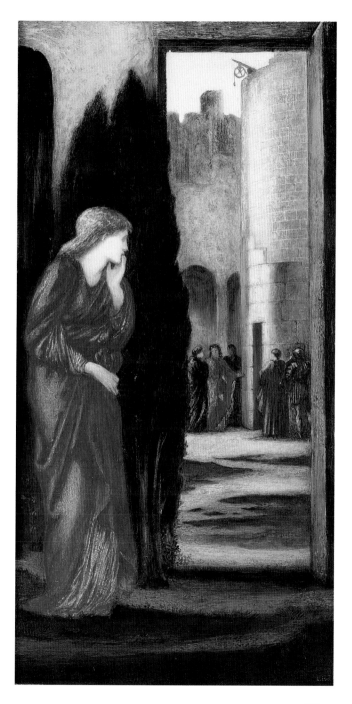

Edward Burne-Jones

27 *Copy of Malory's 'Morte d'Arthur'* with decorated
 covers, half bound in white pigskin, mahogany
 boards painted in oil, and silver bosses and clasps,
 36 × 26 cm

Malory's *Morte d'Arthur* was a favourite source of
subjects for Rossetti and his followers. It provided the
inspiration for the Union murals and it gave Morris the
theme for his only surviving finished oil painting and the
title of his first published book of poetry *The Defense of
Guenevere* (1858). Burne-Jones, too, took subjects from
Malory for a number of his paintings. This edition,
printed by Ballantyne and Hanson after Caxton's edition
of 1485 and bound at the Doves Bindery in 1896, came
from Burne-Jones's own library in The Grange at
Fulham. The front cover has a picture of the round table;
the back cover illustrates a knight searching for the holy
grail.

Pre-Raphaelites and aesthetes

Millais's links with Oxford and the Combes faded as his London ties increased. Rossetti, too, seems to have lost his taste for Oxford. But Hunt continued to sell his work to the Combes and to visit them in Walton Street. In 1895, he advised the keeper of the University Galleries about the best method for displaying the Pre-Raphaelite collection, bequeathed by Mrs Combe in 1893, and was consulted, again, in 1905, when the collection was rehung against a Morris paper. Ruskin had already given many of his own Pre-Raphaelite drawings to the Art School set up in the University Galleries, largely at the instigation of Dr Acland. These drawings, which were intended to instruct the students in the principles of good taste and right thinking, included an important group by Rossetti as well as forty-seven drawings by Burne-Jones to illustrate a proposed edition of *The Earthly Paradise*. Outside the museum, Burne-Jones's work as a designer can also be seen in the chapel windows at St Edmund Hall and Manchester College and in the cathedral and in the Morris tapestries in Exeter College and Rhodes House.

Perhaps because his work was so accessible or because his art had a languorous charm which appealed to undergraduates and gifted amateurs, it was Burne-Jones, not Hunt who marked the direction which art took in the *fin-de-siècle*. The Middle Ages were not as fashionable then, as they had been, but, in this respect, Burne-Jones had taken the initiative by turning to neo-pagan themes in the early 1860s and by depicting them with the graceful contours which he admired in fifteenth century Renaissance prints and drawings. *The Earthly Paradise* inspired writers of the generation of

Swinburne and Walter Pater whose ideal of beauty, part Greek and part Renaissance, was influenced by the principles of Ruskin. This was also the ideal of artists and designers like Charles Ricketts and Walter Crane who followed Morris in trying to reconcile art and craft at the end of the century. Although many of the younger generation, the aesthetes, who followed Pater into a cult of pure art, tended to reject the earnestness of the Pre-Raphaelites and although the neo-Renaissance taste which they cultivated had other sources apart from Morris and his circle, the cult of design, which affected all aspects of public life in late Victorian England, would not have existed and would not have taken the form it did without the example of the Pre-Raphaelites.

Edward Burne-Jones

28 *Head of a Woman*
Gold paint on purple, prepared ground, 32 × 21 cm

In his later years, Burne-Jones often drew on coloured grounds in imitation of the metal point drawings of the Early Renaissance. Burne-Jones gave this drawing, and a number from the same period, to his close friend, Helen Mary Gaskill, who bequeathed it to the Ashmolean in 1939.

Aubrey Beardsley
1872–1898

A Faun
Designed as a vignette for
an edition of Malory's
Morte d'Arthur

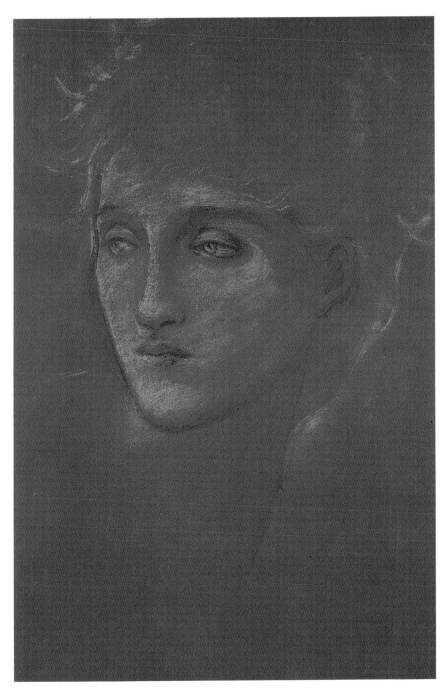

Walter Crane 1845–1915

29 *Shelley's Tomb in the Protestant Cemetery in Rome*
Body colours, 24 × 34 cm
Inscribed: ROMA/1873; and signed in monogram

Crane painted this view of the Protestant cemetery in
Rome during his honeymoon in Italy in 1872–3. Like a
number of other views which date from this visit, the
Protestant Cemetery is painted with a Ruskinian eye for
detail. Crane, however, had recently met Morris and
Burne-Jones for the first time and his art had already
begun to move towards the stylised effects of his more
familar book illustration and designs for wallpapers,
textiles and ceramics. Like William Bell Scott's views of
the tombs of Keats and Shelley, also in the Ashmolean,
Crane's work acknowledges the cult of these Romantic
poets which was not confined to the Pre-Raphaelites but
which they appropriated.

John Everett Millais

The Eve of St Agnes
An illustration for
Moxon's edition of the
poems of Tennyson

74

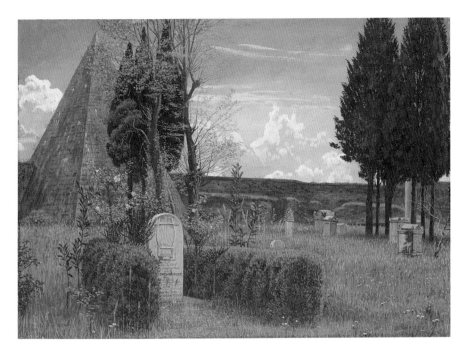

Frederic Sandys 1832–1904

30 *Gentle Spring*
Oil on canvas, 121 × 64 cm

Sandys, a painter and illustrator from Norwich, became a member of Rossetti's circle in 1857. He shared Rossetti's rooms at 16 Cheyne Walk for most of 1866 before quarrelling and parting company with his master. The background of *Gentle Spring* was painted in the garden of the writer, George Meredith, when his friendship with Rossetti was still close. Sandys exhibited it at the Academy exhibition of 1865 with a sonnet by Algernon Swinburne who had joined Rossetti's circle at the same time as Sandys:

> 'O Virgin Mother! of gentle days and nights
> Spring of fresh buds and Spring of soft delights,
> Come, with lips kissed of many an amorous hour
> Come, with hands heavy from the fervent flower
> The fleet first flower that feels the wind and sighs
> The tenderer leaf that draws the sun and dies!'

The figure probably represents Proserpine whose return from the Underworld, in Greek mythology, accompanies the return of Spring. Swinburne's poem was inspired by the painting but the poet did not respond to a darker element in Sandys picture indicated by the shadow of winter, draining from the landscape, the poppies, emblems of sleep and death, and the general sense of transience which pervades the details. The landscape is painted with a Pre-Raphaelite truthfulness, but the figure is inspired by Greek or Roman statuary.

Charles de Sousy Ricketts 1866–1931

31 *Pendant*
Gold and enamel, set with semi-precious stones and
linked to three suspended, baroque pearls, 5 cm (diam)
Inscribed: CR

Like Walter Crane, Charles Ricketts was typical of the
artist-craftsman in the generation after Morris who
combined several talents in painting, illustration and
design. Most of his jewellery was made between 1900 and
1908 for specific clients. The Ashmolean pendant was
designed by Ricketts in 1900 for Mrs Llewellyn Hacon,
wife of Rickett's partner in The Vale Press, and made by
Carlo and Arthur Giuliano. It carries her portrait in a
gold medallion, gem-set and enamelled in the manner of
the sixteenth century jewels which Ricketts admired.

Charles Fairfax Murray
1849–1919

*Half-length study of a
woman with a stringed
instrument*

78

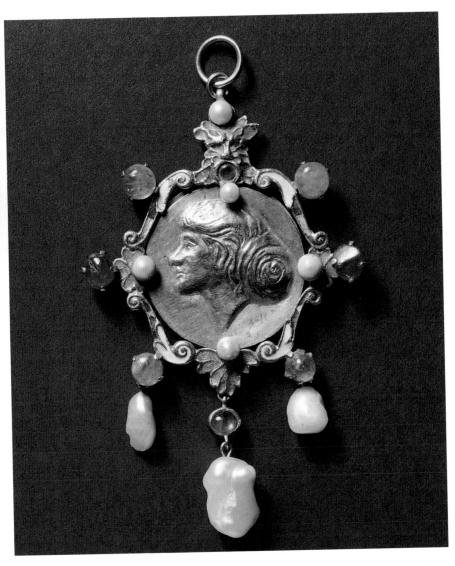

Although there are no footnotes in this book, the text depends heavily on the work of others. Those who wish to know more should consult the following:

Allen Staley *The Pre-Raphaelite Landscape* (Oxford 1973), John Christian *The Pre-Raphaelites in Oxford* (Oxford 1974), *The Pre-Raphaelites* (Tate Gallery, 7 March – 28 May 1984), *The Pre-Raphaelites in Oxford* (Tokyo, Shiga, Osaka 1987). I have also received help from Miss Noelle Brown, Mr Michael Maclagan, Dr. Nicholas Penny, Miss J.E. Robinson, Commander S.H. Stone, Miss Lucy Whitaker and Mr Paul Woodmansterne for which I am most grateful. All works of art illustrated are in the Ashmolean Museum unless otherwise stated.